Talk That Shit

A Very Petty Coloring Book

**THE CONTENT IN THIS BOOK
IS NOT FOR FUCKING KIDS**

**THIS BOOK IS MADE FOR
ENTERTAINMENT
ONLY**

All rights reserved

Color Test Page

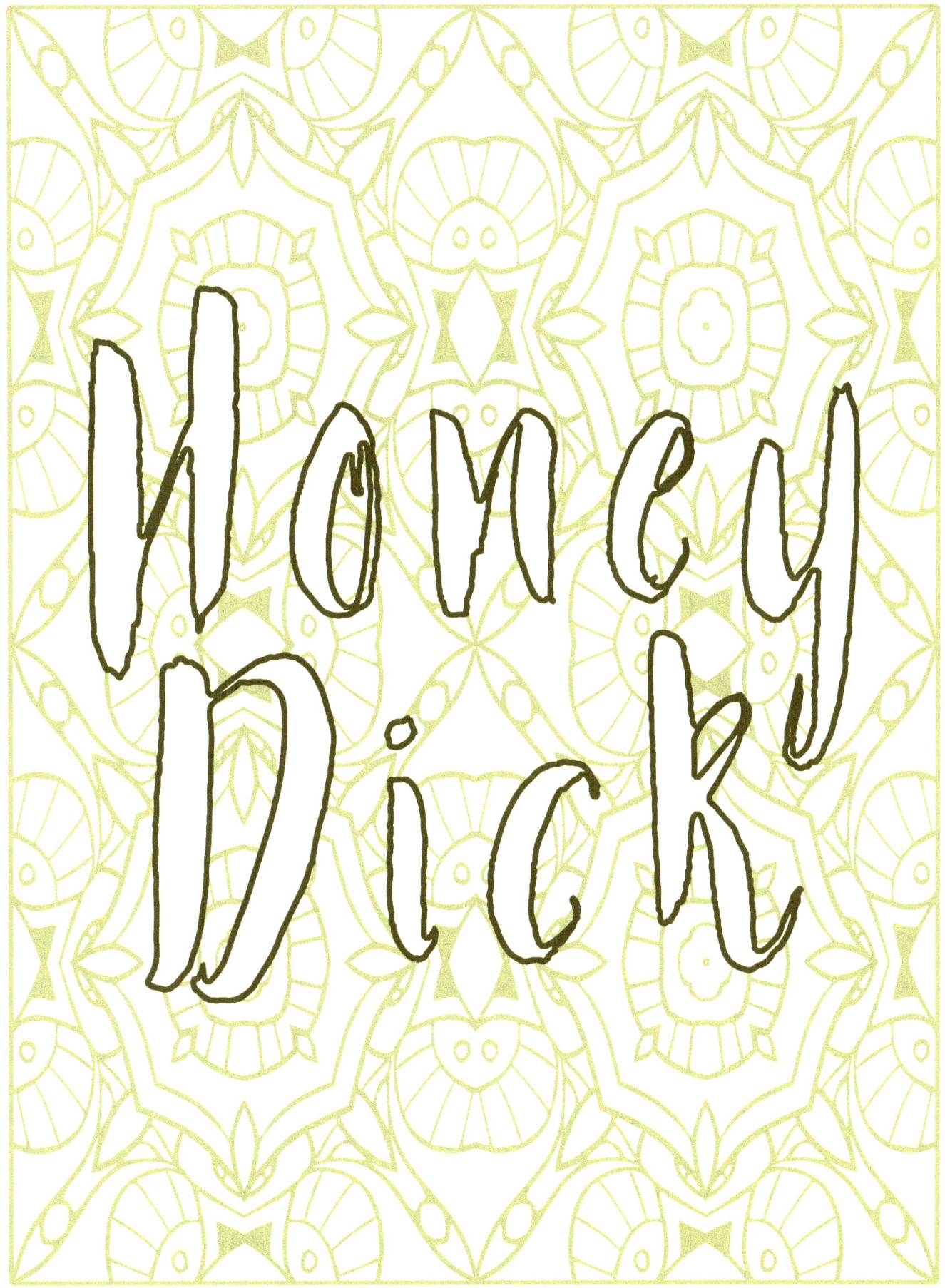

www.ingramcontent.com/pod-product-compliance
Lightning Source LLC
Chambersburg PA
CBHW080545190526
45169CB00007B/2643